Listen and Color
Favorite Poems for Children
Book and CD

Illustrated by
Thea Kliros

Dover Publications, Inc.
Mineola, New York

Bibliographical Note

Listen and Color: Favorite Poems for Children Book and CD is a new work, first published by Dover Publications, Inc., in 2004.

DOVER *Pictorial Archive* SERIES

International Standard Book Number: 0-486-43891-0

Manufactured in the United States of America
Dover Publications, Inc., 31 East 2nd Street, Mineola, N.Y. 11501

NOTE

In this entertaining coloring book and CD set, youngsters can listen to 84 favorite poems and color scenes from 39 of these delightful verses. With the audio compact disc found on the inside back cover, listeners can enjoy such timeless favorites as Lydia Maria Child's "Thanksgiving Day," Eugene Field's "Little Boy Blue," and Lewis Carroll's "The Walrus and the Carpenter." The CD offers a sampling of the most familiar and acclaimed poems written for and about the very young. After listening to the work of many talented and best-loved poets, young readers may even feel inspired to compose a poem of their own or to create a drawing for a poem that is not included in this book. For each scene depicted in the coloring book, a brief excerpt from the poem has been provided.

LIST OF ILLUSTRATIONS

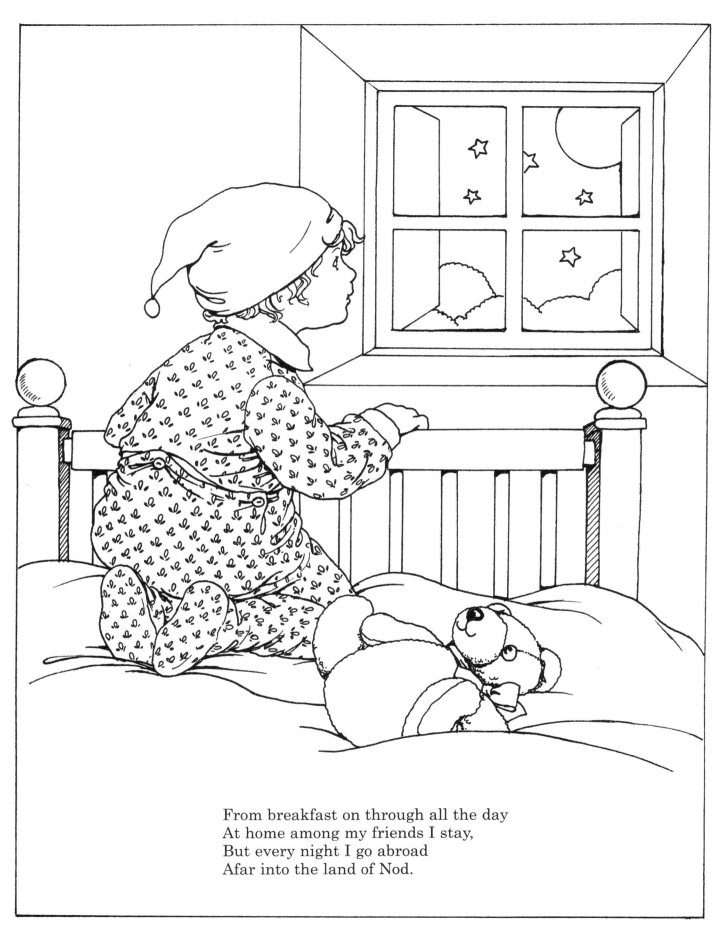

From breakfast on through all the day
At home among my friends I stay,
But every night I go abroad
Afar into the land of Nod.

The Land of Nod by Robert Louis Stevenson 1

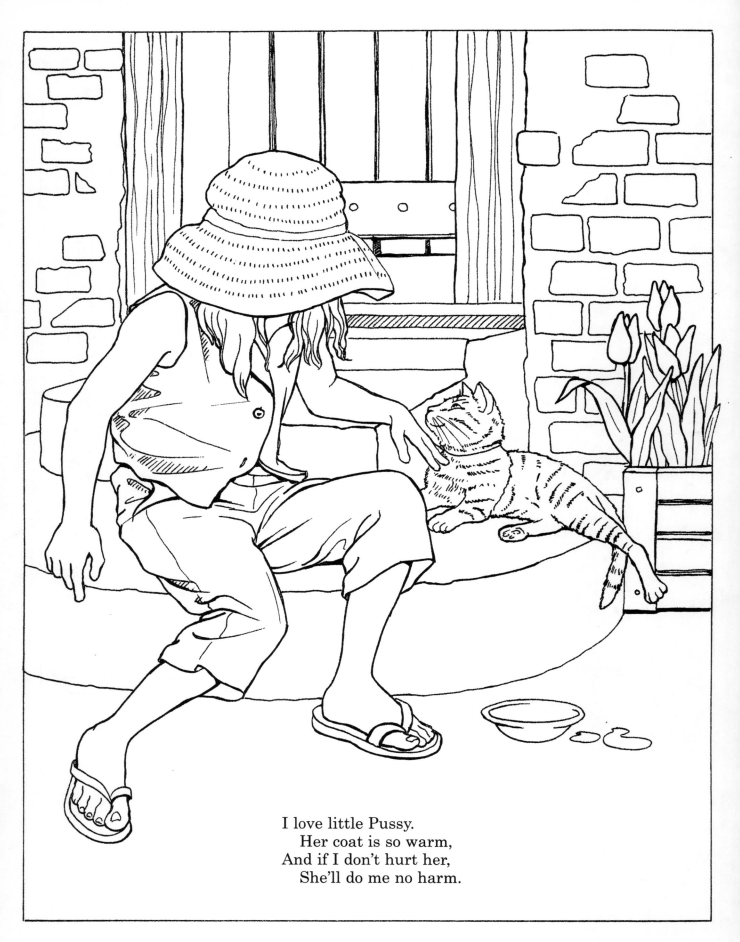

I love little Pussy.
Her coat is so warm,
And if I don't hurt her,
She'll do me no harm.

I Love Little Pussy by Jane Taylor

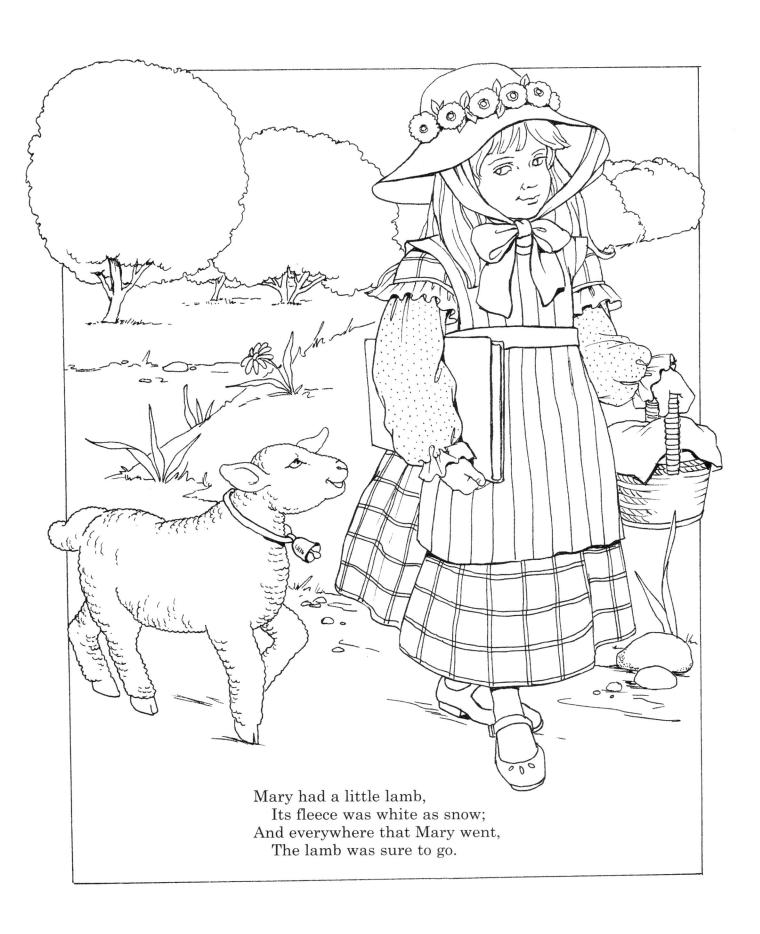

Mary had a little lamb,
 Its fleece was white as snow;
And everywhere that Mary went,
 The lamb was sure to go.

Mary's Lamb by Sarah Josepha Hale 3

Elephants walking
Along the trails
Are holding hands
By holding tails.

Holding Hands by Lenore M. Link

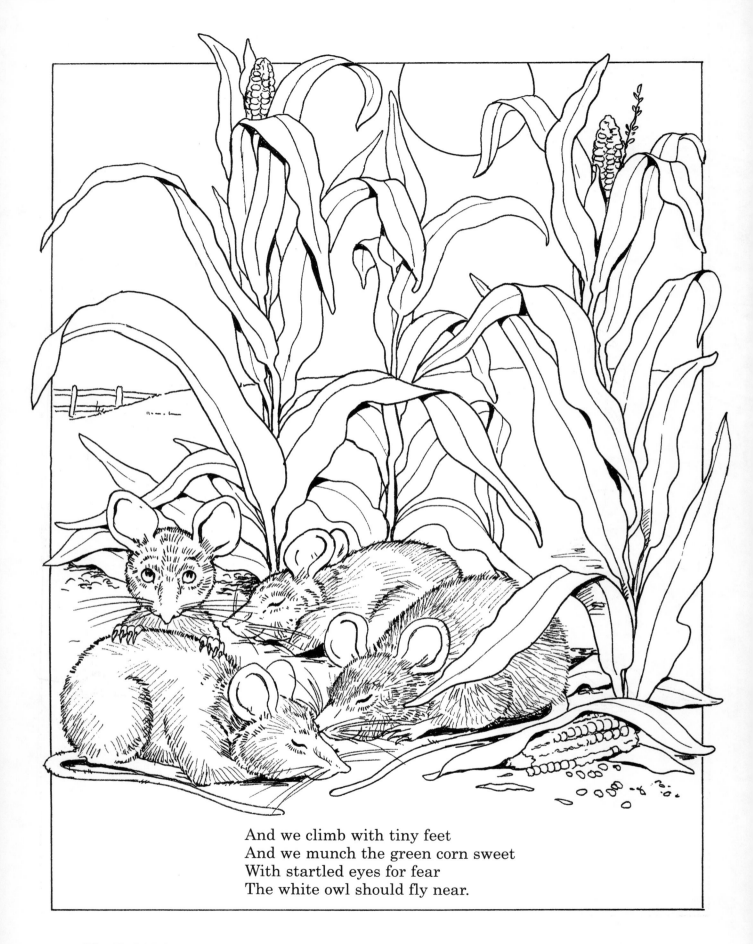

And we climb with tiny feet
And we munch the green corn sweet
With startled eyes for fear
The white owl should fly near.

6 *The Field Mouse* by William Sharp

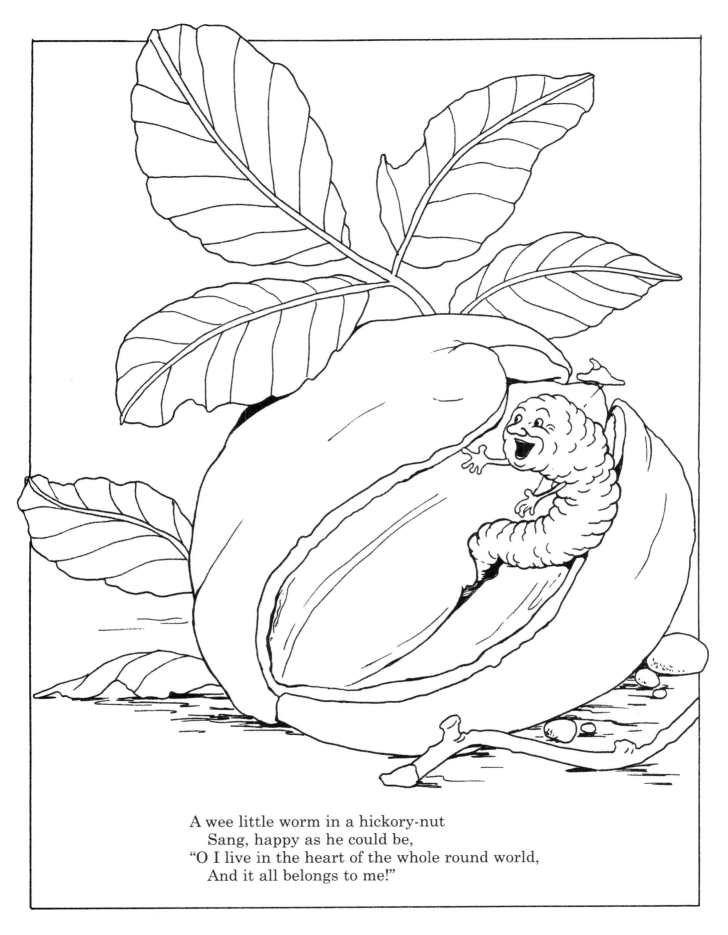

A wee little worm in a hickory-nut
 Sang, happy as he could be,
"O I live in the heart of the whole round world,
 And it all belongs to me!"

A Wee Little Worm by James Whitcomb Riley 7

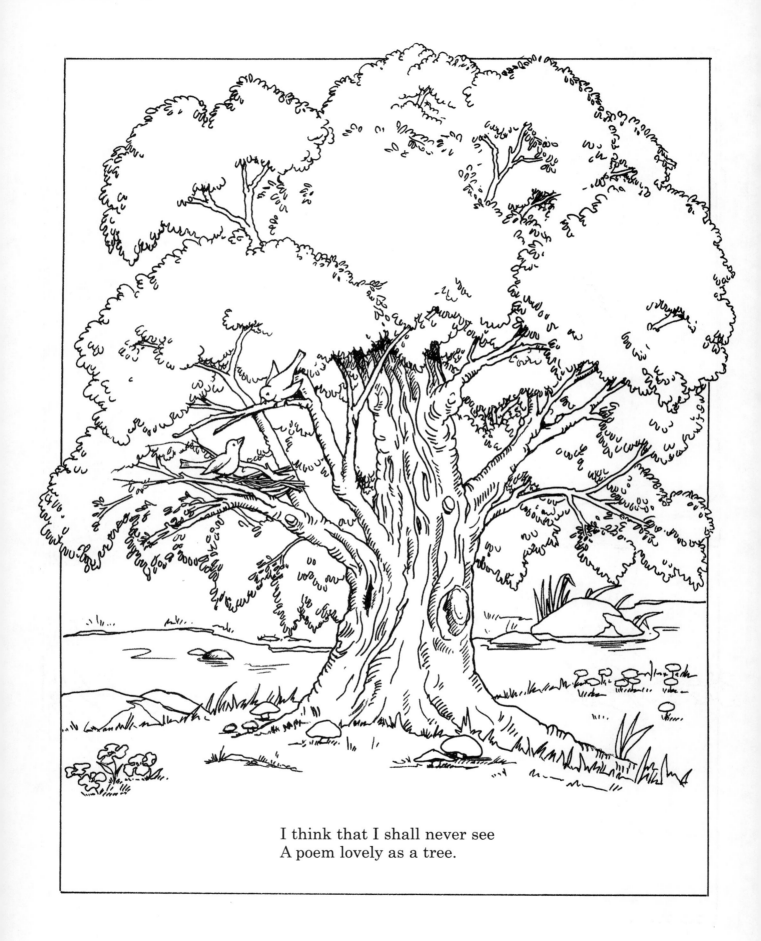

I think that I shall never see
A poem lovely as a tree.

Trees by Joyce Kilmer

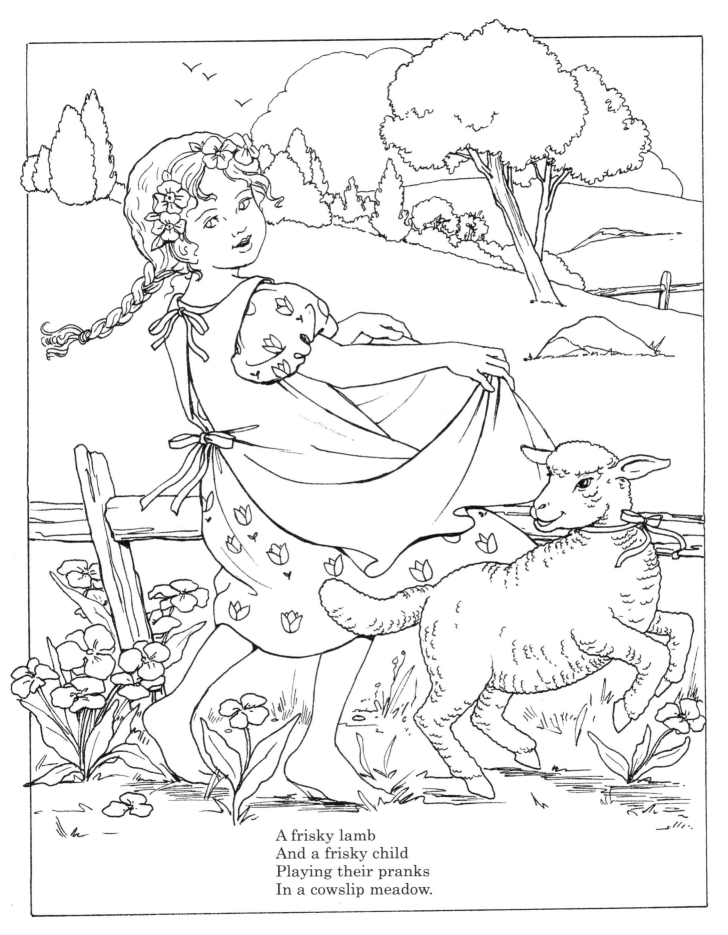

A frisky lamb
And a frisky child
Playing their pranks
In a cowslip meadow.

A Frisky Lamb by Christina Rossetti 9

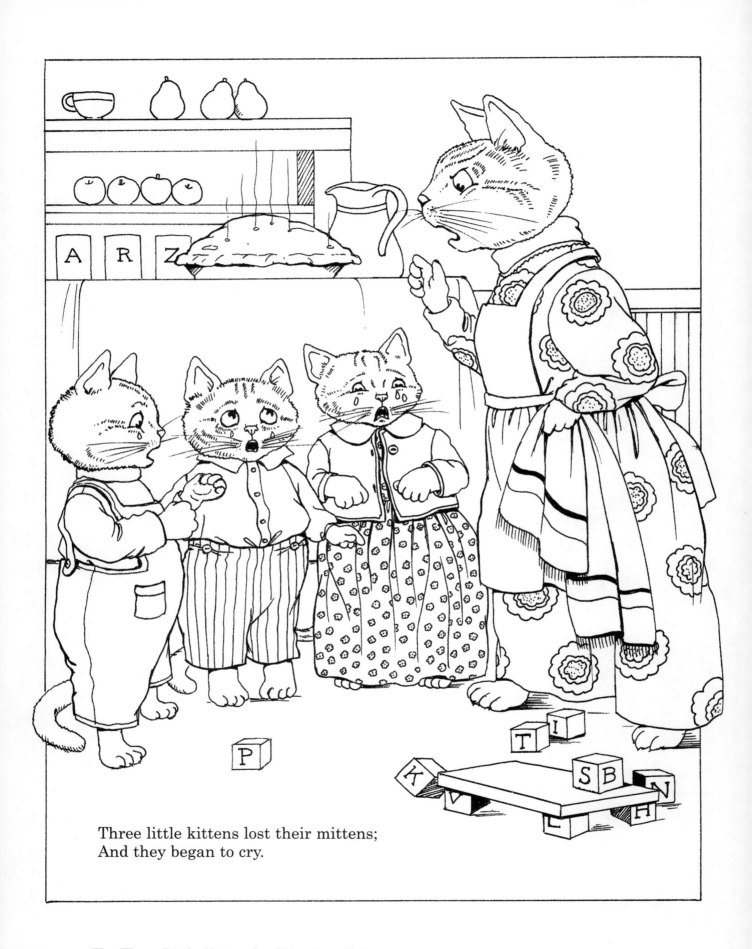

Three little kittens lost their mittens;
And they began to cry.

The Three Little Kittens by Eliza Lee Follen

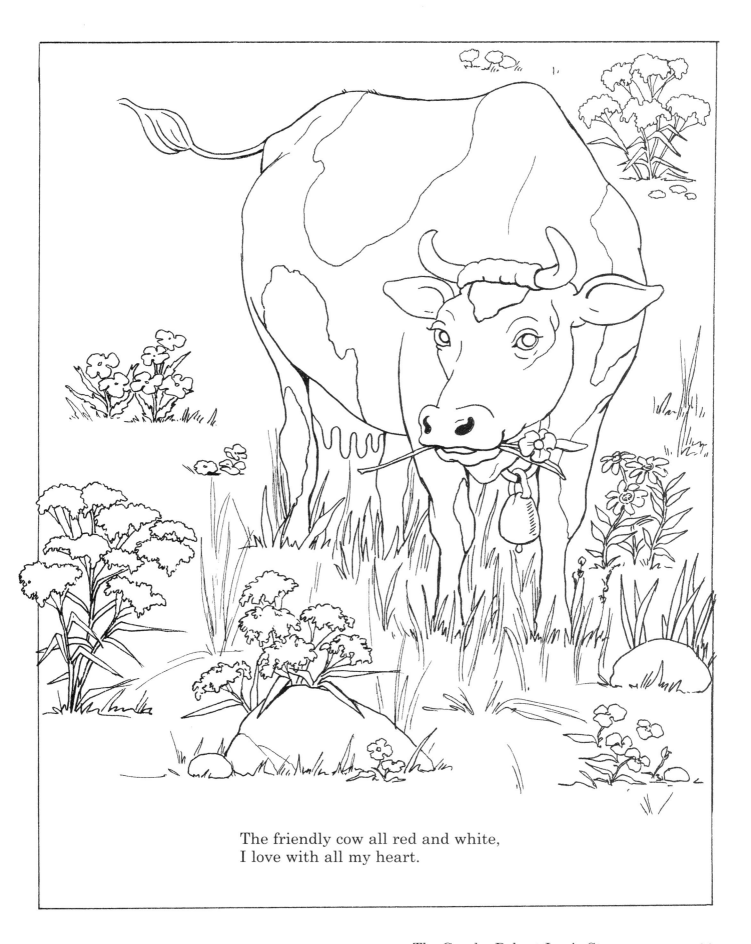

The friendly cow all red and white,
I love with all my heart.

The Cow by Robert Louis Stevenson 11

The gingham dog and the calico cat
Side by side on the table sat.

The Duel by Eugene Field

An old Jack-o'-lantern lay on the ground;
He looked at the Moon-man, yellow and round.

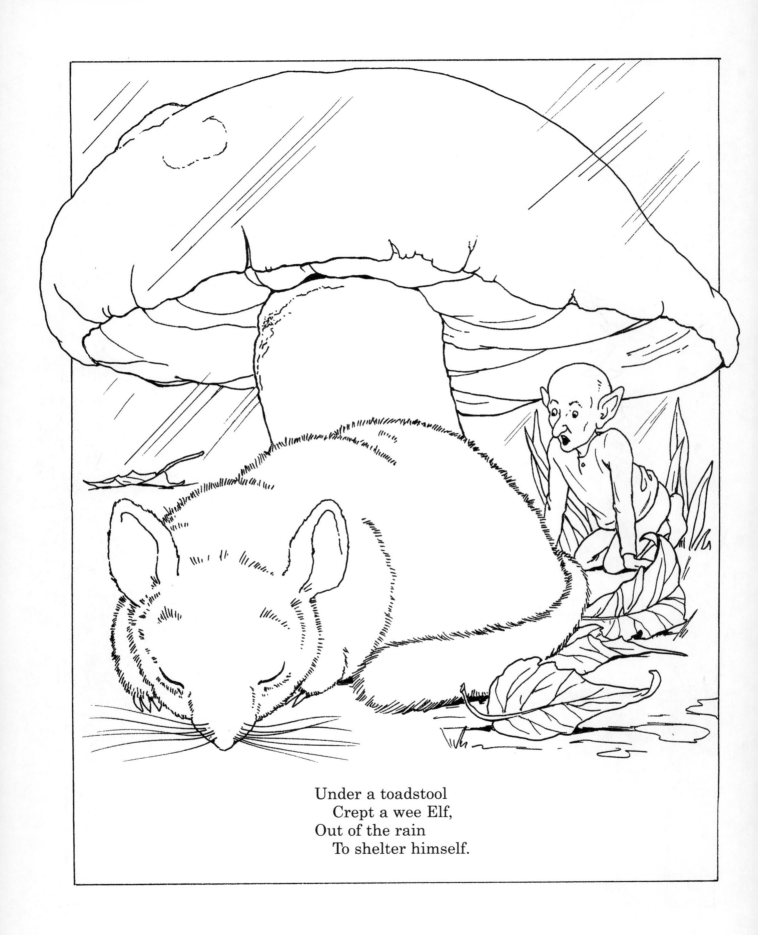

Under a toadstool
　　Crept a wee Elf,
Out of the rain
　　To shelter himself.

14　　*The Elf and the Dormouse* by Oliver Herford

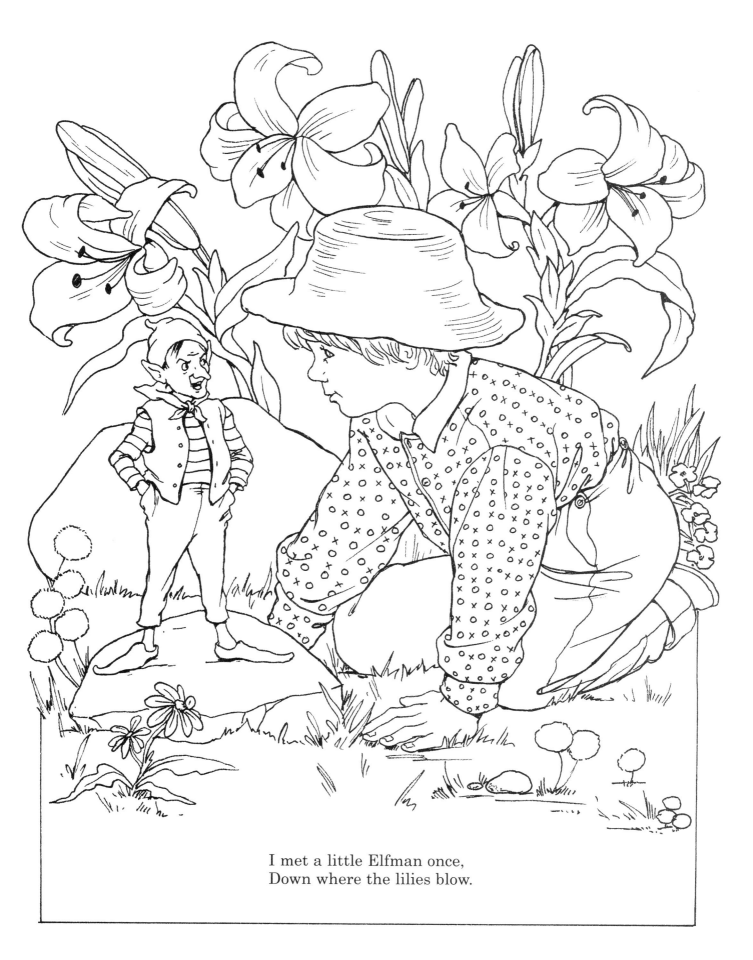

I met a little Elfman once,
Down where the lilies blow.

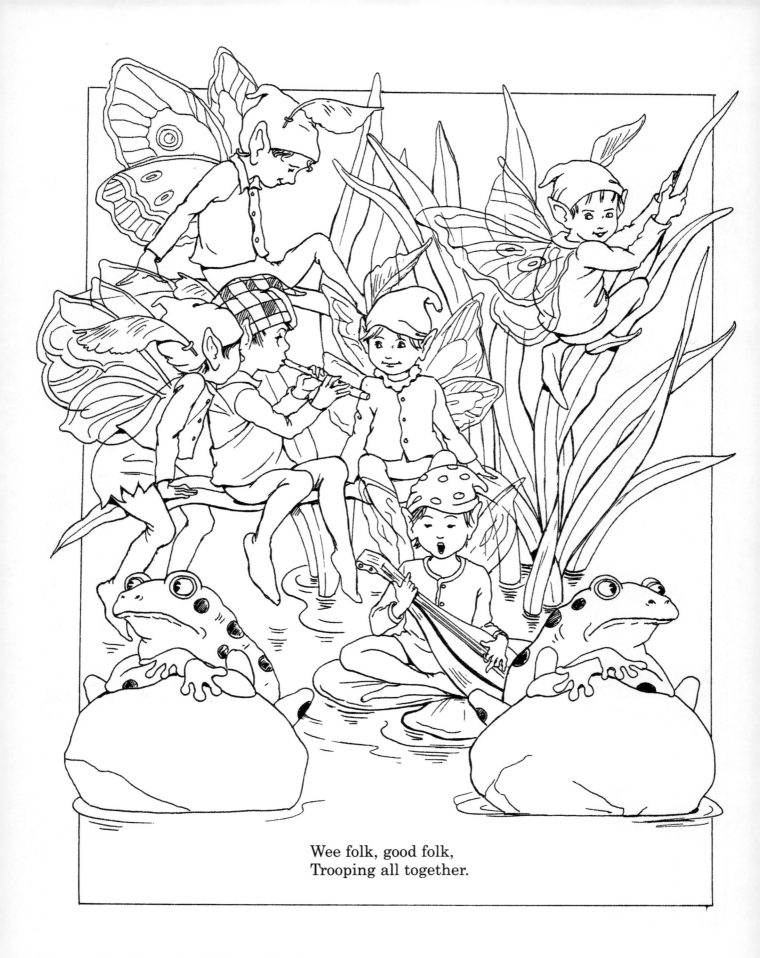

Wee folk, good folk,
Trooping all together.

The Fairies by William Allingham

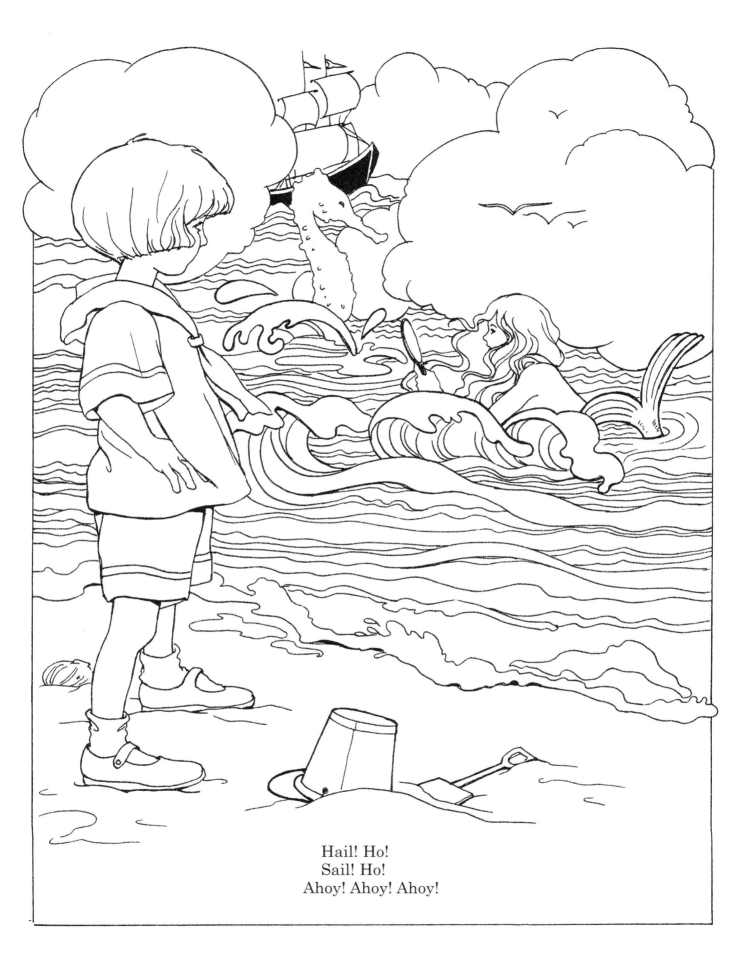

Hail! Ho!
Sail! Ho!
Ahoy! Ahoy! Ahoy!

A Sea-Song from the Shore by James Whitcomb Riley 17

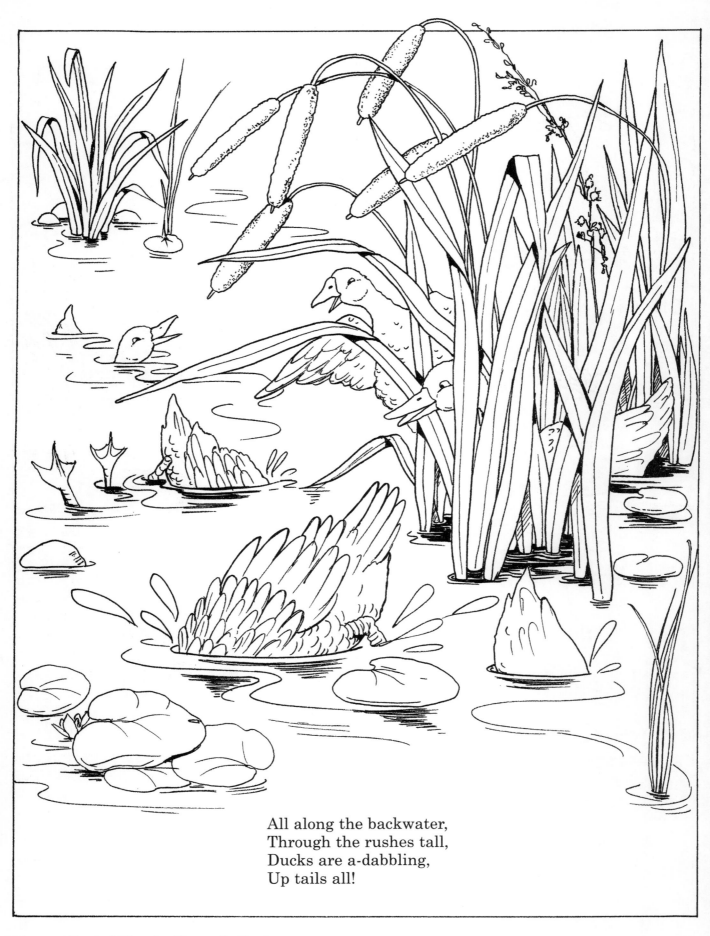

All along the backwater,
Through the rushes tall,
Ducks are a-dabbling,
Up tails all!

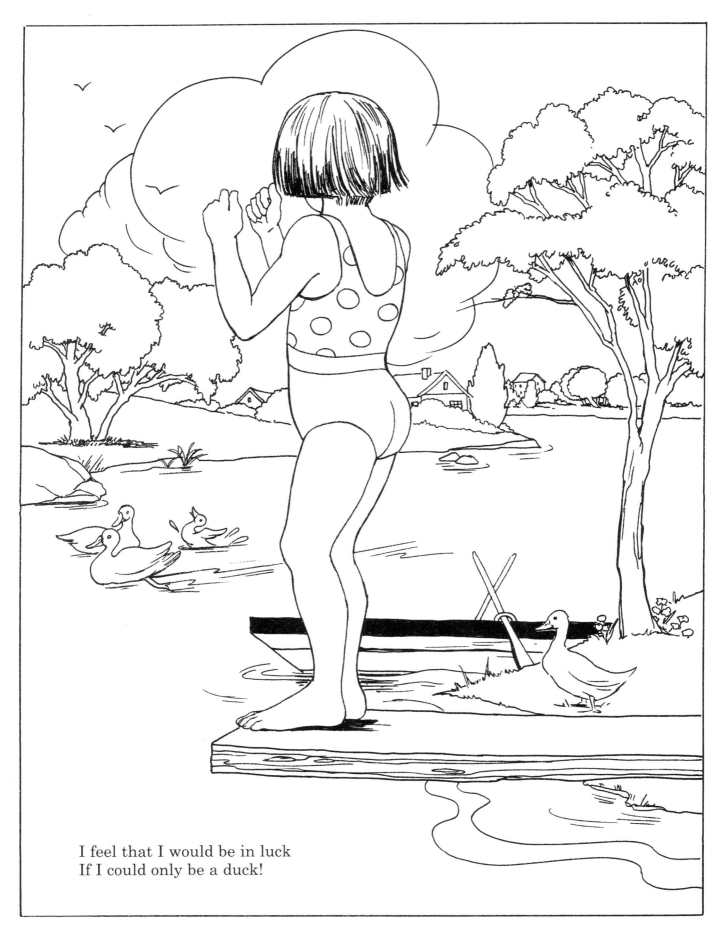

I feel that I would be in luck
If I could only be a duck!

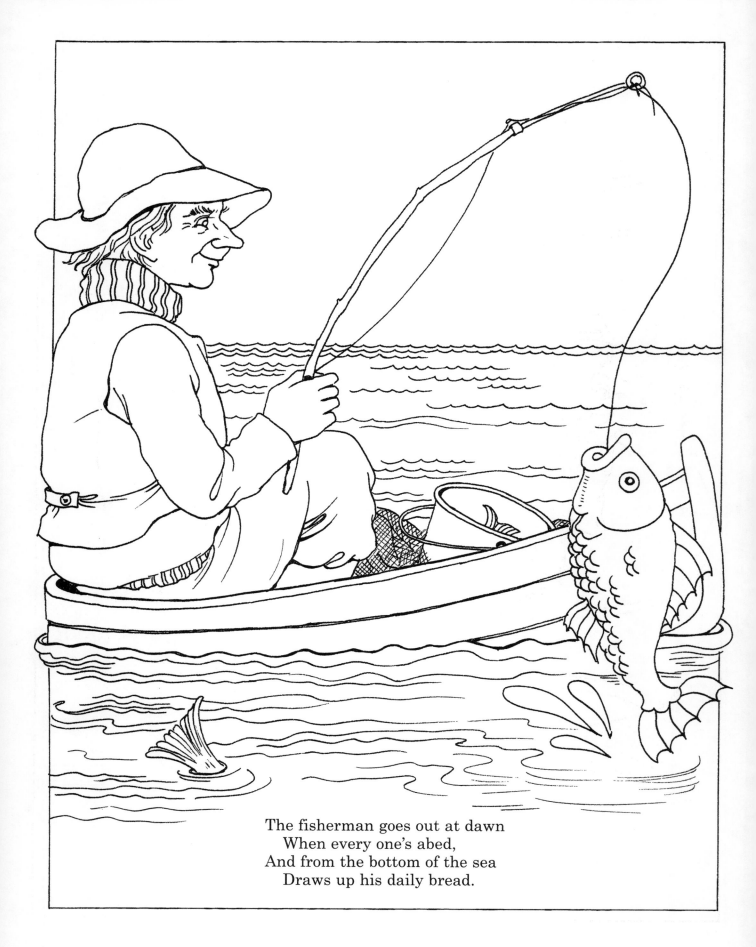

The fisherman goes out at dawn
When every one's abed,
And from the bottom of the sea
Draws up his daily bread.

The Fisherman by Abbie Farwell Brown

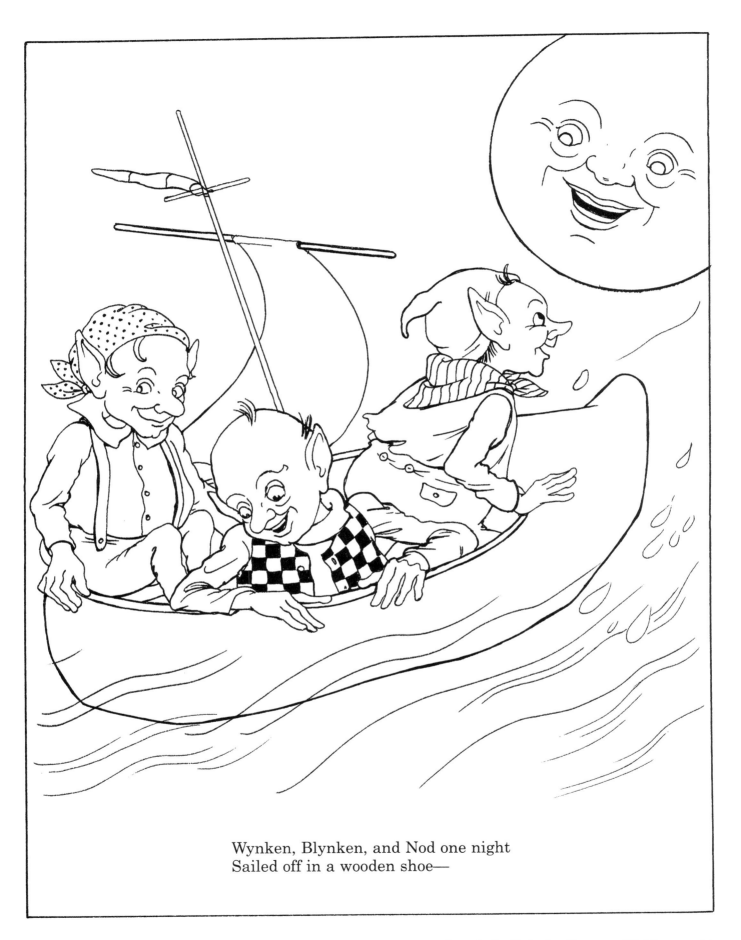

Wynken, Blynken, and Nod one night
Sailed off in a wooden shoe—

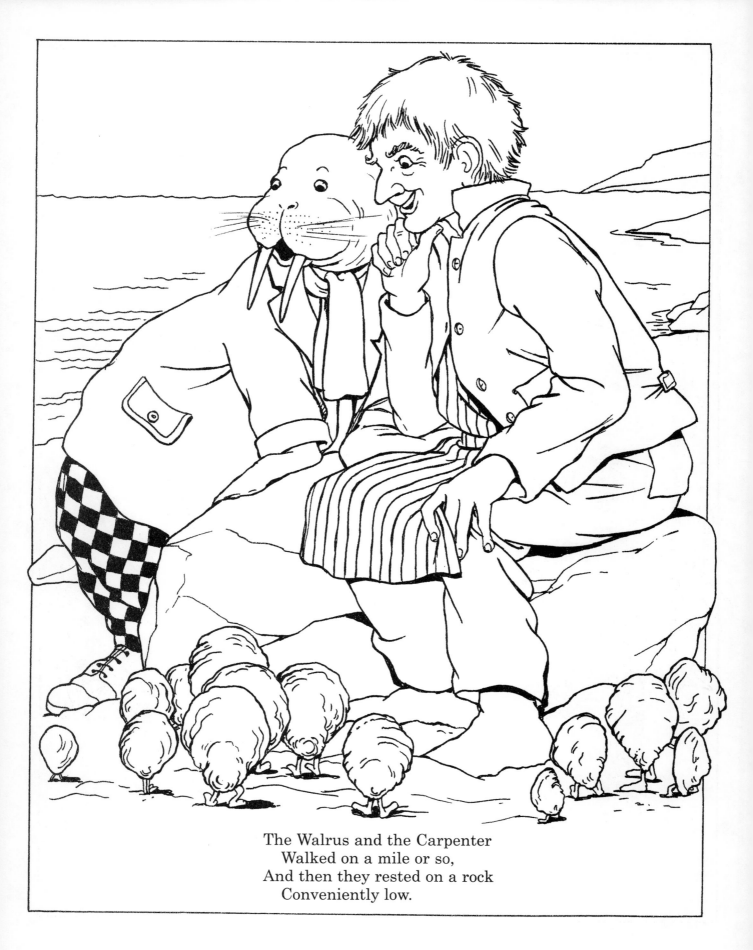

The Walrus and the Carpenter
Walked on a mile or so,
And then they rested on a rock
Conveniently low.

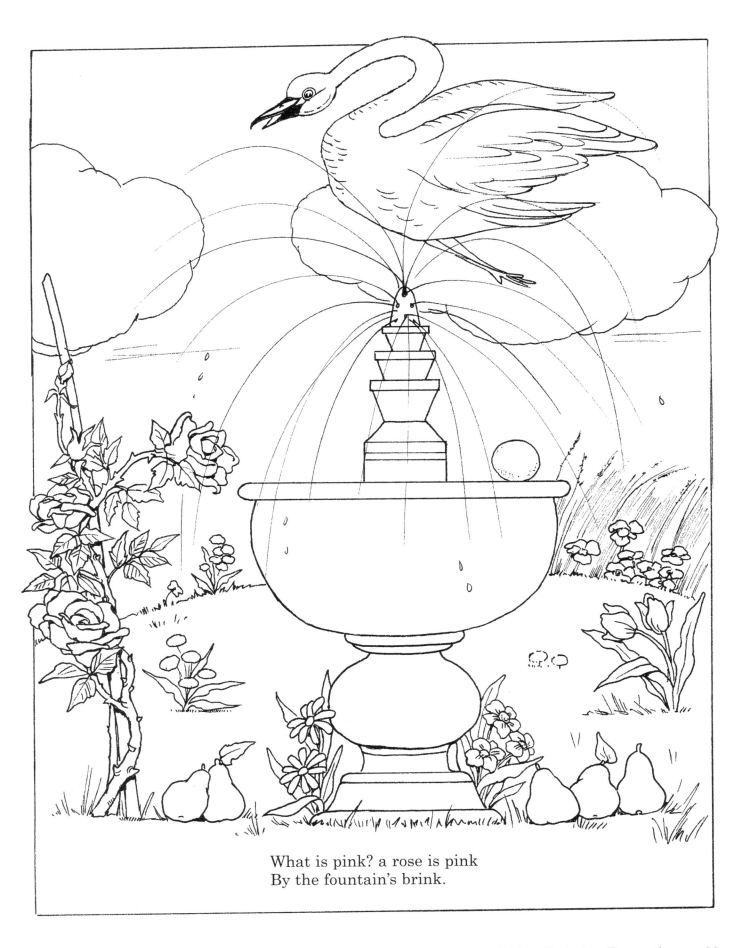

What is pink? a rose is pink
By the fountain's brink.

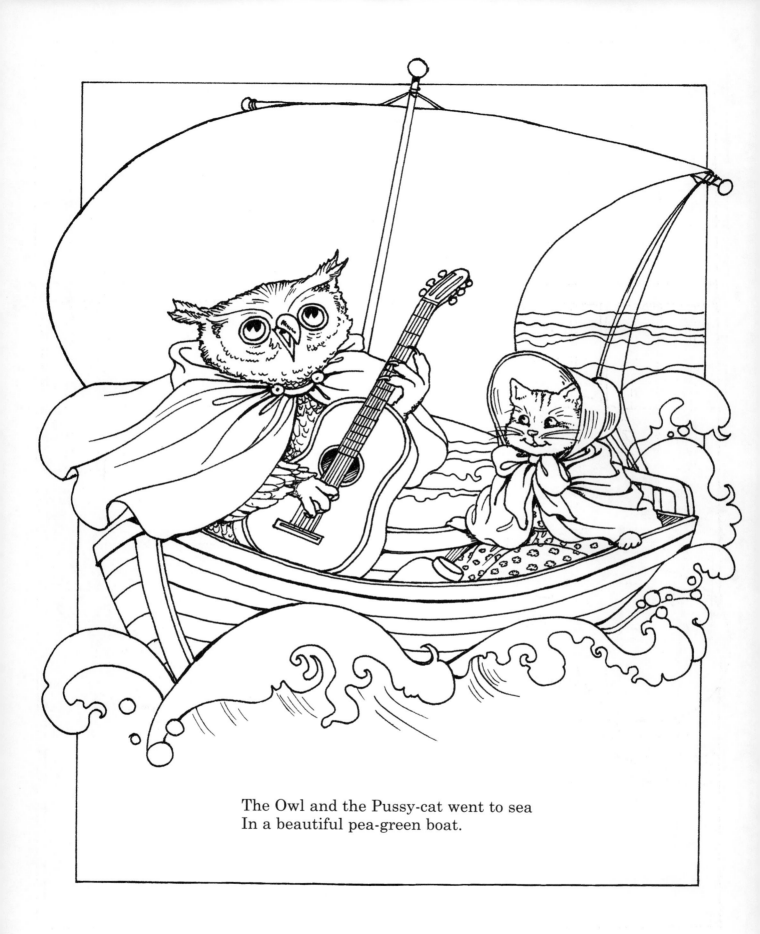

The Owl and the Pussy-cat went to sea
In a beautiful pea-green boat.

24 *The Owl and the Pussy-cat* by Edward Lear

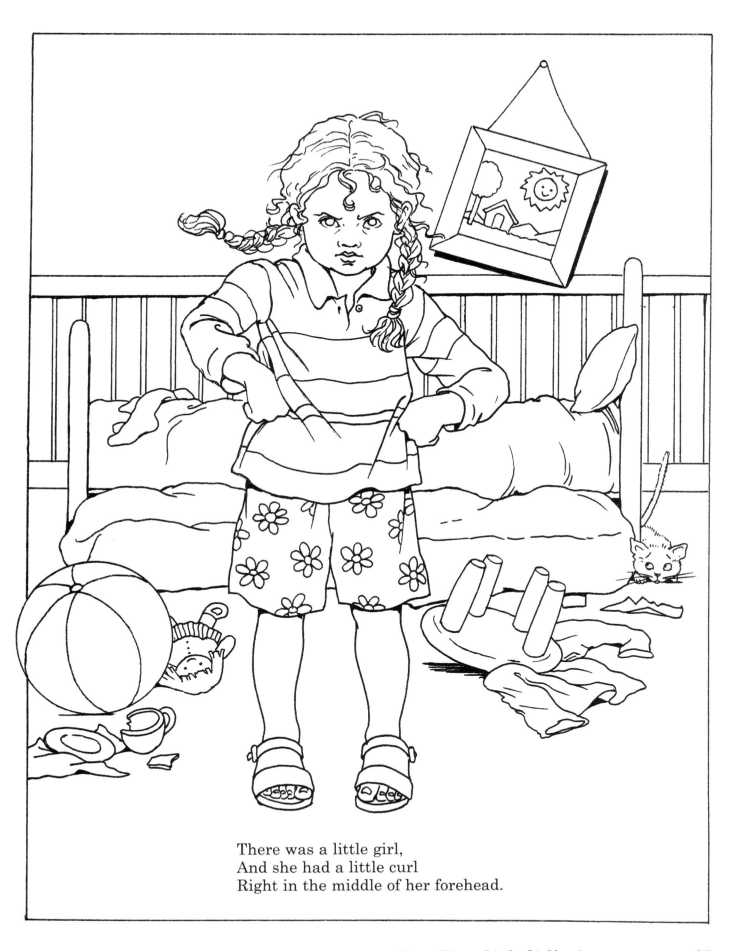

There was a little girl,
And she had a little curl
Right in the middle of her forehead.

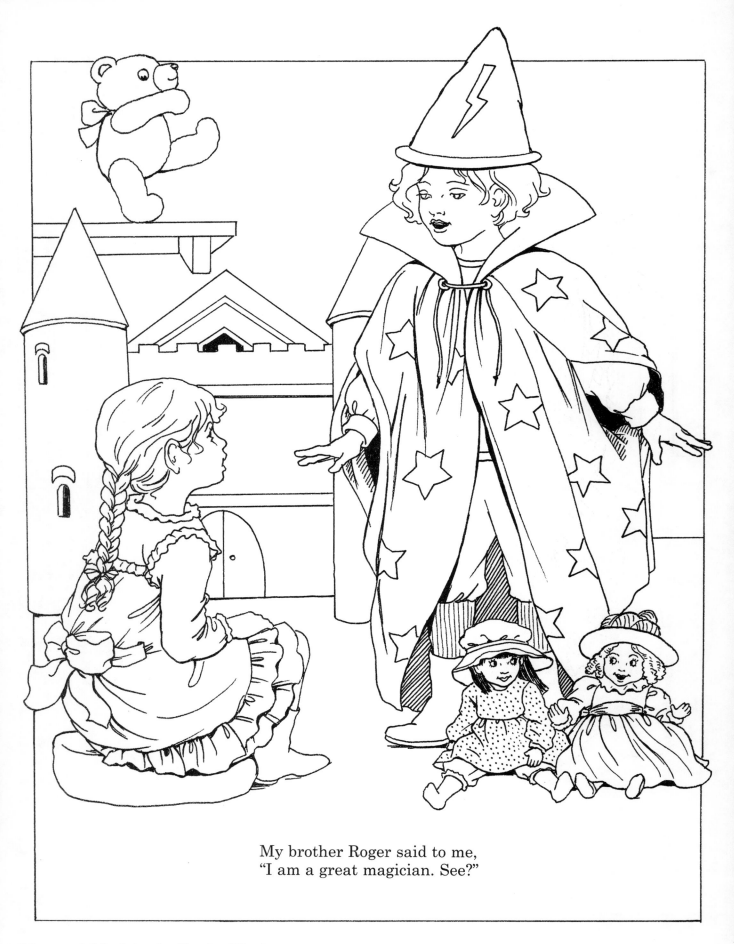

My brother Roger said to me,
"I am a great magician. See?"

A Magician by Eunice Ward

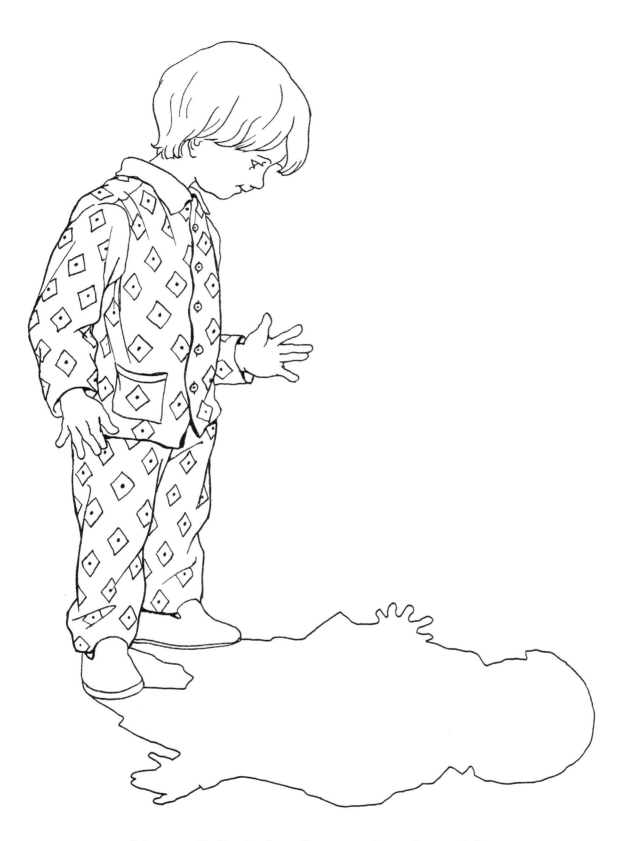

I have a little shadow that goes in and out with me
And what can be the use of him is more than I can see.

My Shadow by Robert Louis Stevenson 27

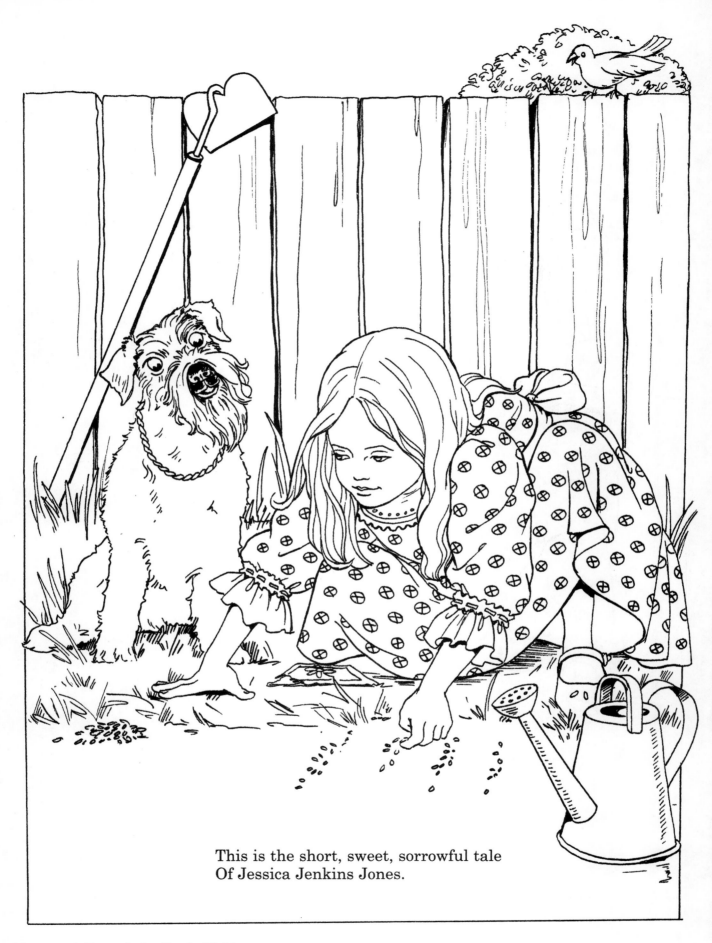

This is the short, sweet, sorrowful tale
Of Jessica Jenkins Jones.

A Tragedy by Doris Webb

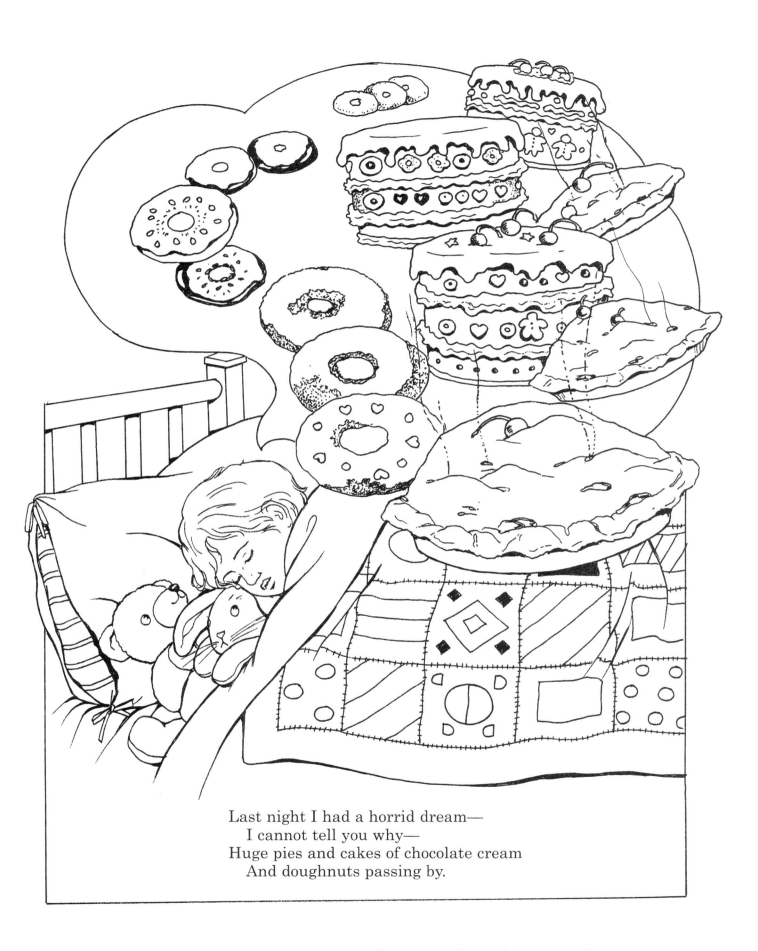

Last night I had a horrid dream—
 I cannot tell you why—
Huge pies and cakes of chocolate cream
 And doughnuts passing by.

The Pantry Ghosts by Frederic Richardson 29

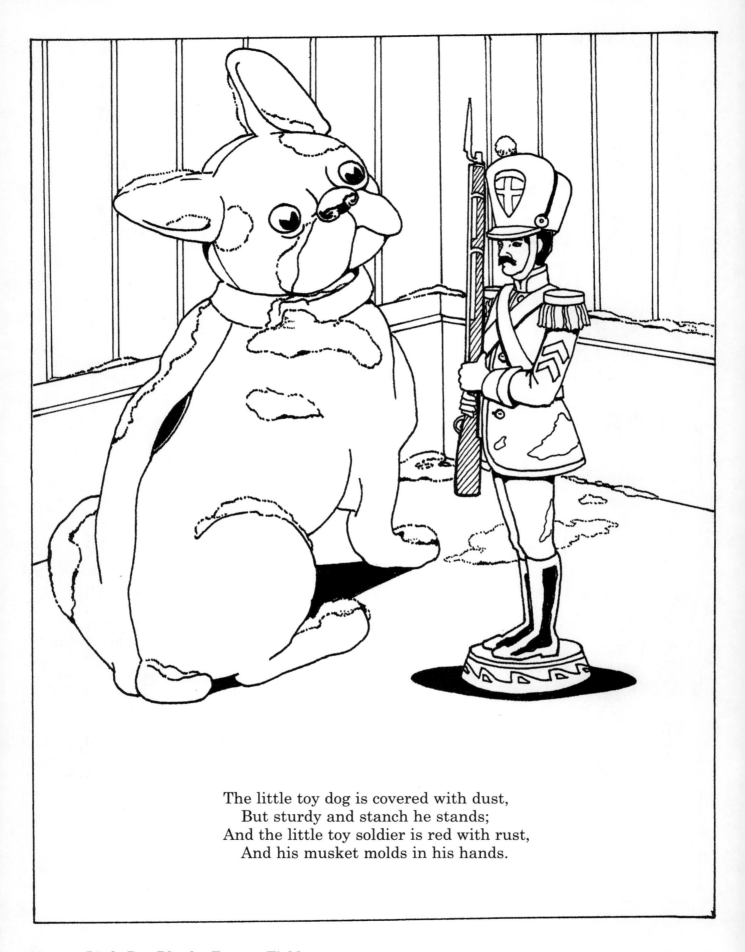

The little toy dog is covered with dust,
But sturdy and stanch he stands;
And the little toy soldier is red with rust,
And his musket molds in his hands.

Little Boy Blue by Eugene Field

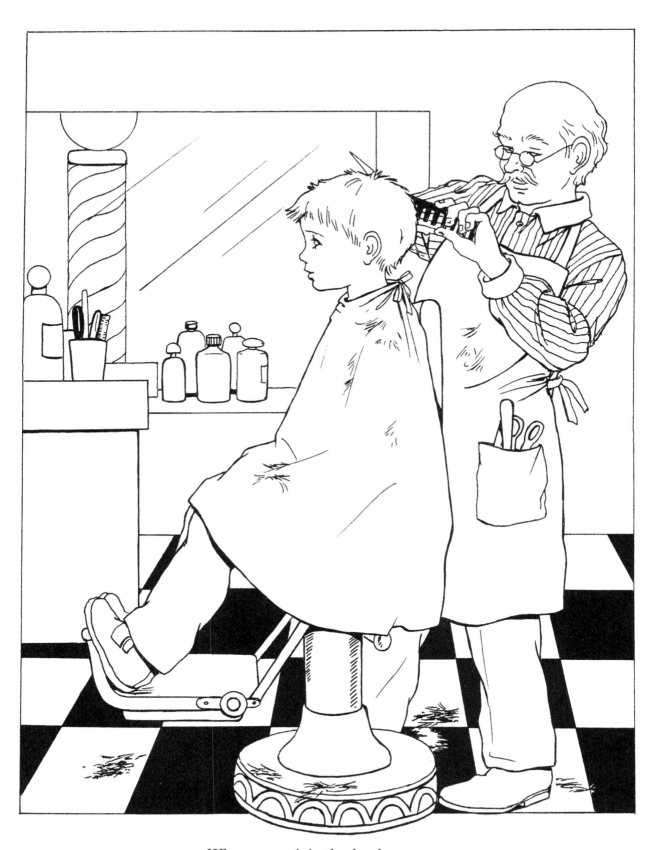

When you visit the barber
 And sit in his chair,
Don't squirm
Like a worm
 While he's cutting your hair.

Barbershop by Martin Gardner 31

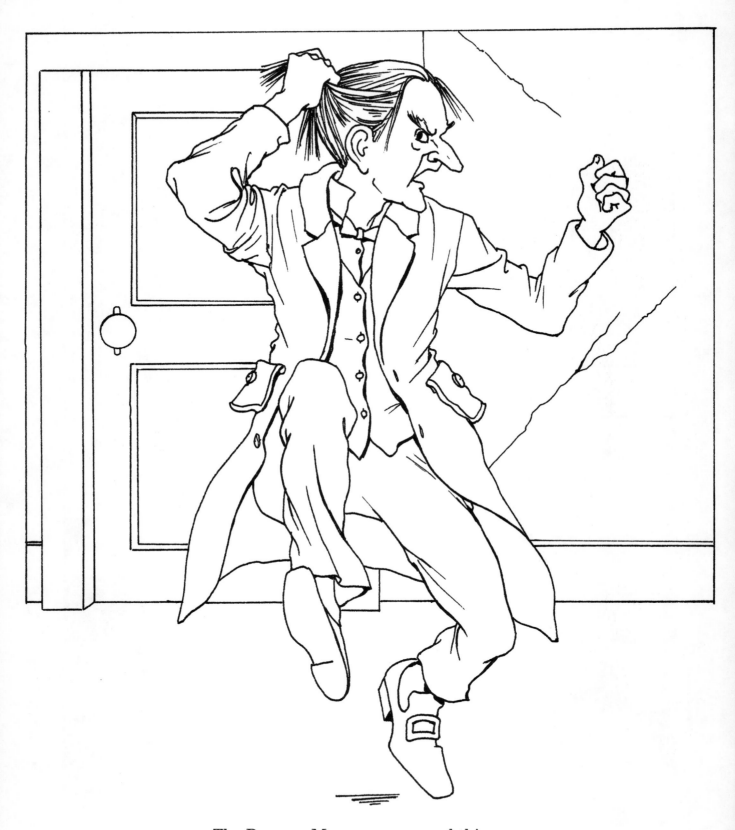

The Peppery Man was cross and thin;
He scolded out and scolded in;
He shook his fist, his hair he tore;
He stamped his feet and slammed the door.

The Peppery Man by Arthur Macy

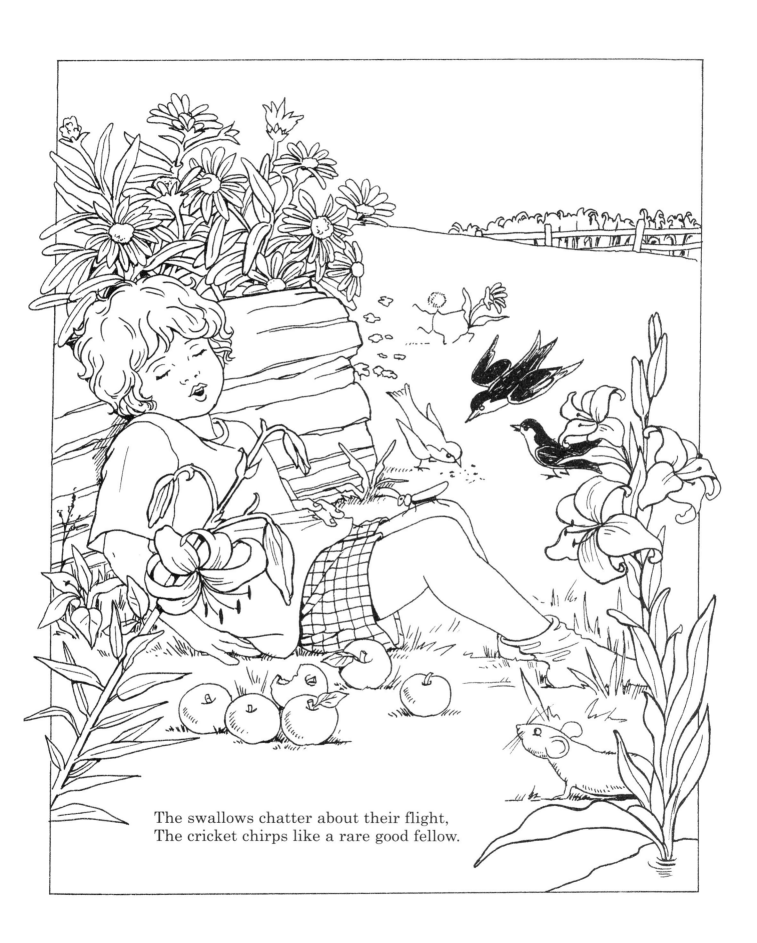

The swallows chatter about their flight,
The cricket chirps like a rare good fellow.

August by Celia Thaxter 33

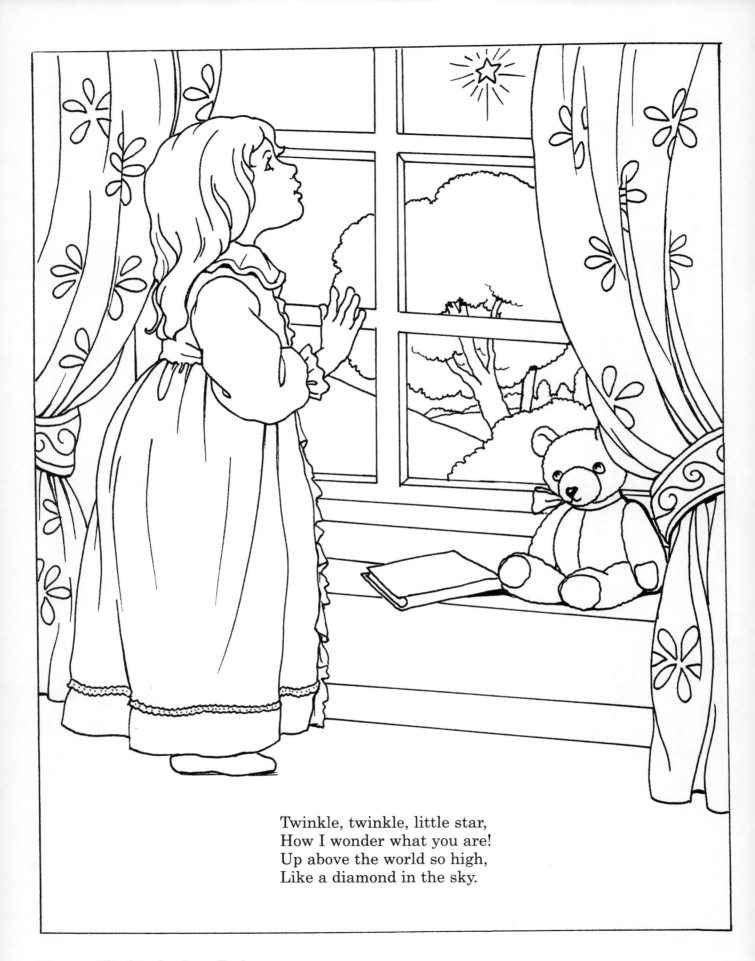

Twinkle, twinkle, little star,
How I wonder what you are!
Up above the world so high,
Like a diamond in the sky.

The Star by Jane Taylor

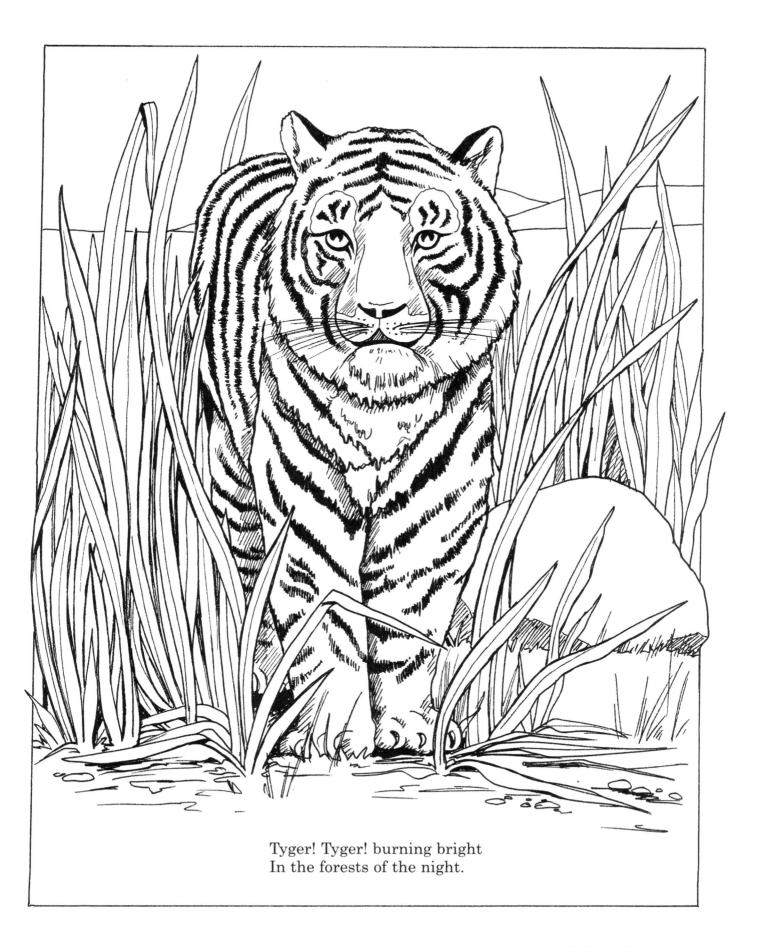

Tyger! Tyger! burning bright
In the forests of the night.

The Tyger by William Blake 35

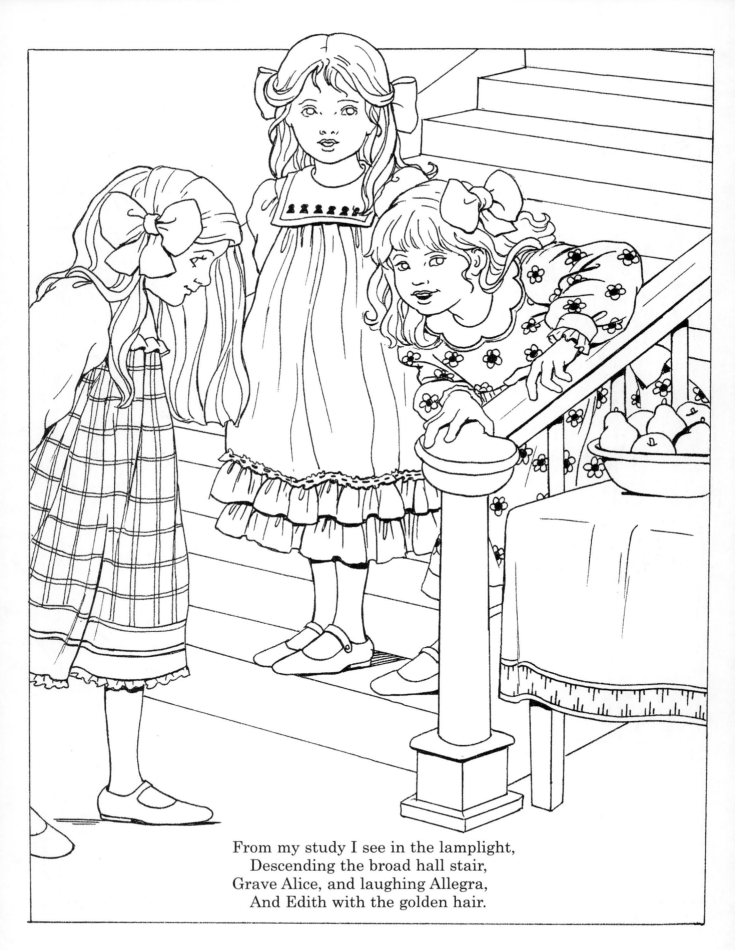

From my study I see in the lamplight,
Descending the broad hall stair,
Grave Alice, and laughing Allegra,
And Edith with the golden hair.

The Children's Hour by Henry Wadsworth Longfellow

Over the river and through the wood,
To grandfather's house we go.

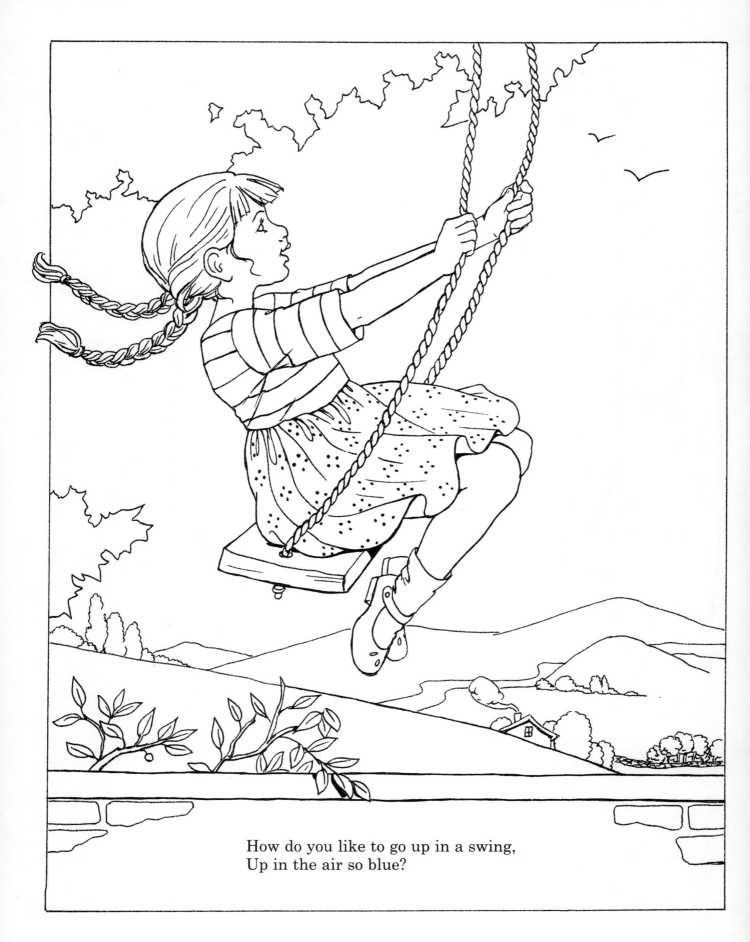

How do you like to go up in a swing,
Up in the air so blue?

The Swing by Robert Louis Stevenson

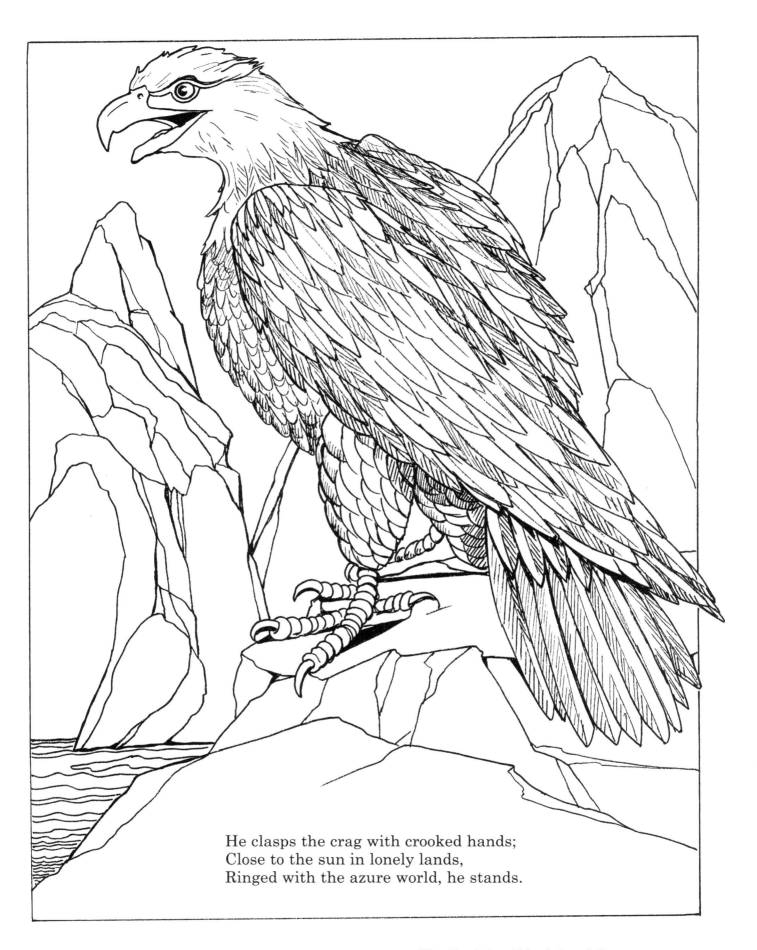

He clasps the crag with crooked hands;
Close to the sun in lonely lands,
Ringed with the azure world, he stands.

The Eagle by Alfred, Lord Tennyson 39

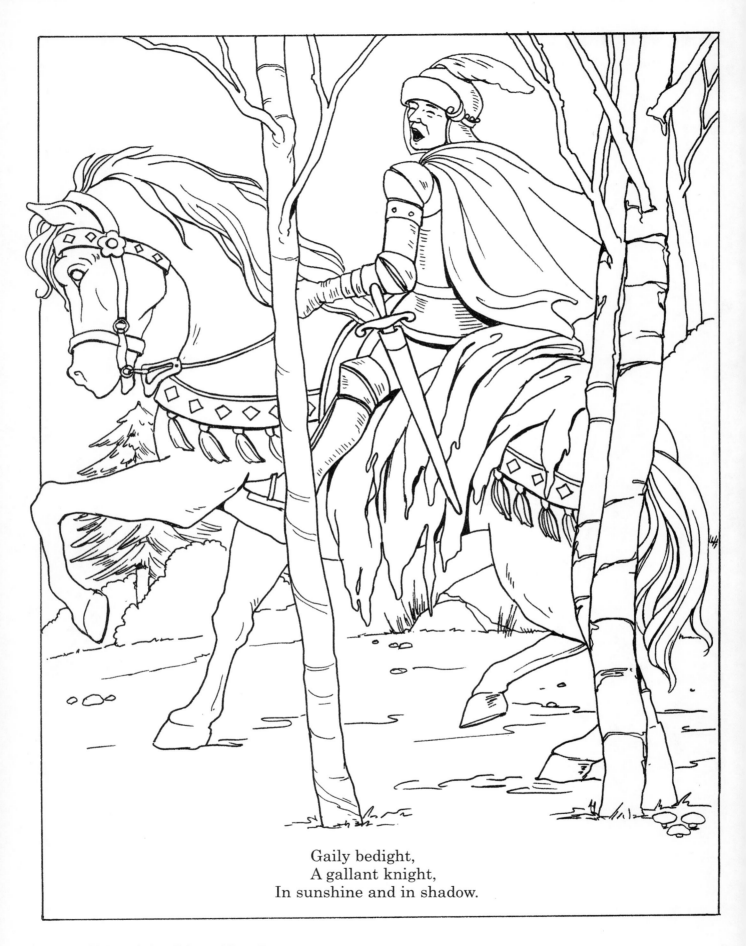

Gaily bedight,
A gallant knight,
In sunshine and in shadow.

LIST OF TRACKS ON CD

*Note: Only those poems listed in **boldface type** are illustrated in the coloring book.*

1. **The Land of Nod,** Robert Louis Stevenson
2. Hurt No Living Thing, Christina Rossetti
3. The Cat of Cats, William Brighty Rands
4. **I Love Little Pussy,** Jane Taylor
5. **Mary's Lamb,** Sarah Josepha Hale
6. **Holding Hands,** Lenore M. Link
7. **The Field Mouse,** William Sharp
8. Mr. Finney's Turnip, Anonymous
9. What Do We Plant?, Henry Abbey
10. **A Wee Little Worm,** James Whitcomb Riley
11. **Trees,** Joyce Kilmer
12. Trees, Sara Coleridge
13. **A Frisky Lamb,** Christina Rossetti
14. Whisky Frisky, Anonymous
15. Nurse's Song, William Blake
16. **The Three Little Kittens,** Eliza Lee Follen
17. There Were Two Ghostesses, Anonymous
18. Jabberwocky, Lewis Carroll
19. Only One Mother, George Cooper
20. **The Cow,** Robert Louis Stevenson
21. Tomorrow's the Fair, Anonymous
22. **The Duel,** Eugene Field
23. The Moon's the North Wind's Cooky, Vachel Lindsay
24. Mr. Moon, Bliss Carman
25. **Judging by Appearances,** Emilie Poulsson
26. The Dinkey-Bird, Eugene Field
27. **The Elf and the Dormouse,** Oliver Herford
28. **The Little Elf,** John Kendrick Bangs
29. **The Fairies,** William Allingham
30. An Unsuspected Fact, Edward Cannon
31. Minnie and Winnie, Alfred, Lord Tennyson
32. **A Sea-Song from the Shore,** James Whitcomb Riley
33. **Ducks' Ditty,** Kenneth Grahame
34. **Swimming,** Clinton Scollard
35. If, Anonymous
36. **The Fisherman,** Abbie Farwell Brown
37. O Sailor, Come Ashore, Christina Rossetti
38. In the Night, Anonymous
39. **Dutch Lullaby,** Eugene Field
40. **The Walrus and the Carpenter,** Lewis Carroll
41. Laughing Song, William Blake
42. The Man in the Wilderness, Anonymous